Wild Flowers

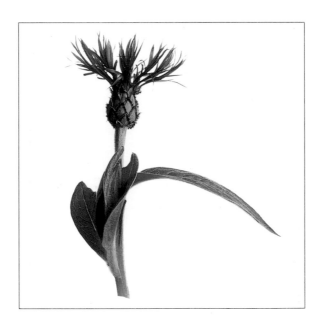

Wild Flowers

by Snowdon

Foreword by Sir Roy Strong

Clarkson Potter/Publishers
New York

To Lucy

Published by Clarkson N. Potter, Inc., 201 East 50th Street,
New York, New York 10022.
Member of the Crown Publishing Group.

Random House, Inc. New York, Toronto, London, Sydney, Auckland.

CLARKSON N. POTTER, POTTER, and colophon are trademarks of
Clarkson N. Potter, Inc.

Originally published in Great Britain by Pavilion Books Limited in 1995

Designed by Raymonde Watkins

Manufactured in Italy by Graphicom

Library of Congress Cataloging-in-Publication Data is available upon request.

ISBN 517-70565-6

10 9 8 7 6 5 4 3 2 1

First American Edition

Foreword

The earliest published account of an attempt at photography by Humphry Davy in 1802 tells us that the subject was a botanical one. Whether that was a flower we are not told, but from the earliest successful experiments with the new medium flowers were to form a recurring *leitmotif*. William Henry Fox Talbot, one of the founding fathers of photography, wrote of his flower pictures: 'I have practised this art since the year 1834.'

The migration of flowers to the new art of photography came at precisely the period when five centuries of botanical illustration, through woodcut, engraving, etching and lithography, had reached its apogee. Ironically, there was to be a firm resistance to photography taking over from illustration and it was not to be until the 1920s and 30s, when reliable colour was more freely available, that that resistance was finally overcome. Even so, the full potential of what is known as *Flora Photographica* only began to be realized in the 1950s.

Snowdon's wild flowers belong within this tradition, a tradition which is far more complicated than at first glance it would seem. In Snowdon's case, these are arranged images taken within the studio, where the photographer hasn't held

back from bending a stem or plucking off an aesthetically offending petal in pursuit of a perfect picture. So, in one sense these are invented flowers, wild flowers transformed by means of photographic tools and techniques.

They evoke, too, the traditional role of flowers, interpreted and idealized as geometric constructs, in the history of ornament. In this way Snowdon's wild flowers are neither an accurate botanical record nor an environmentalist's plea for their preservation. Rather, they are emotionless and detached explorations of form, line, colour and texture which move strongly in the direction of graphic textile design which arranges leaves and flowers as a linear pattern. They recall inevitably the work of people like William Morris.

Snowdon's photographic preoccupation has led him to flatten his three-dimensional subjects in such a way that the prime impression of each picture depends on silhouette. The result of this exploration of part of the realm of nature cannot be described as anything other than delightful.

Sir Roy Strong, 1995

Photographer's note

I treated the wild flowers in this little book in the same way as the people I photograph – trying to emphasize each individual quality and most flattering angle and to capture on film the colour or shape I most admired. Sometimes, to achieve the simple contours I wanted without altering the expressions I wished to illustrate, I bent stalks and leaves slightly as one would flatter a sitter. Occasionally I let the flowers wilt a little so that they drooped into the geometric or romantic shapes I wanted.

Like nineteenth-century photographers, who used head-clamps to stop their sitters from moving, I made a contraption of clips, wires and clothes pegs to help the flowers 'perform' for the camera.

Always using the simplest possible source of light, I chose to photograph the flowers starkly in a studio against a white background, rather than in their natural habitat.

Wild Flowers

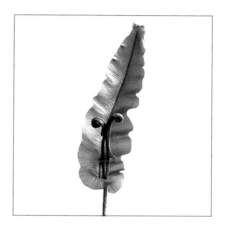

COLUMBINE

*In close-up the spurred nectaries at the rear of the flower
reveal clearly how the plant acquired its names. The old English
'columbine' or 'dove's plant' acknowledges the resemblance
to a cluster of pigeons: John Gerard in his* Herball *described 'five
little horns standing upright, of the shape of little birds'.
Botanical Latin preferred to see these forms as eagle's claws –
hence 'aquilegia'.*

*Aquilegias are wildly promiscuous, and new variants are always
appearing to intrigue plant lovers. Even in Gerard's day,
in the sixteenth century, when only a handful of species were
known, doubles, bicolours and other decorative forms were pro-
duced, including frilled granny's bonnets,
'rose' types, and 'starry' flowers, which were spurless.*

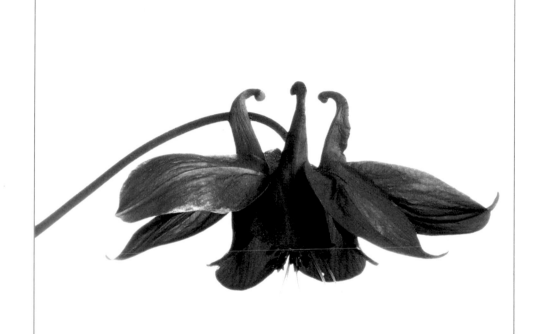

HART'S-TONGUE FERN

The coiled fronds unfurl into undivided, tongue-shaped leaves.
Hart's-tongues are among the handsome hardy evergreen
species that Victorian fern fanciers might obtain from 'the tempting
basket of the itinerant fern vendor' – if they did not collect
them themselves.

They might plant them in the sort of outdoor
fernery advocated by the garden writer Shirley Hibberd. The style of
this should be rustic rather than refined, suggesting wildness
and apparent neglect – 'up to a certain point' . . . for 'dirt and
disorder are as injurious to the ferns as to the morals of those who
encourage such things, but primness is not desirable in a fernery'.

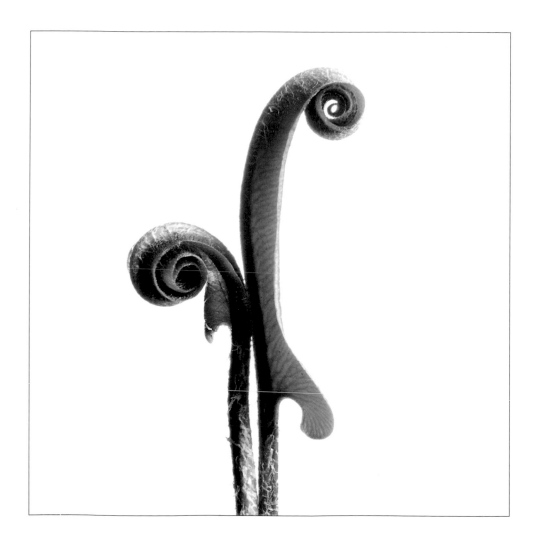

LEOPARD'S BANE

The plants we now call leopard's bane – genus Doronicum *–
produce sunny, daisy-like flowers in spring. We grow them for
decoration rather than to dig them up to vanquish leopards. It was
the root you needed for this purpose: it was supposed to
resemble a scorpion, and thus to poison troublesome beasts of prey.*

*Evidently it also perplexed fellow scorpions: William Turner's
sixteenth-century* Herbal *claimed that 'Leopardes bayne layd to a
scorpione maketh hyr utterly amased and Num'. To confuse
scorpions, leopards and people even further, other plants – arnica
and herb Paris – were also named 'leopard's bane'.*

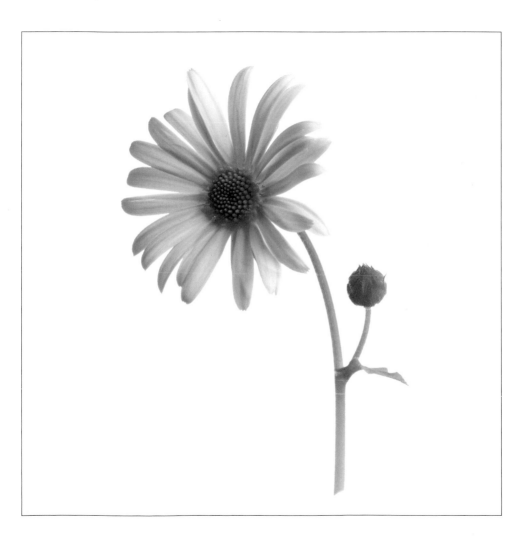

STINGING NETTLE

*You could dress in clothes woven from nettle fibre, sup
on nourishing nettle soup, eat the young leaves cooked spinach-
fashion and refresh yourself with nettle beer. You might prefer
to wear gloves during the preparation of all this as protection from
the stinging hairs, which inject an irritant mixture of formic
acid and histamine beneath the skin with the action of a
hypodermic needle. (The hair tip is sharpened with silica to
glass-like hardness that breaks when touched, allowing the soft
hair base to squeeze out its liquid contents.)*

*But Roman soldiers stung themselves deliberately
to simulate warmth in the British cold, and Greek maidens
did likewise as a Good Friday penance.*

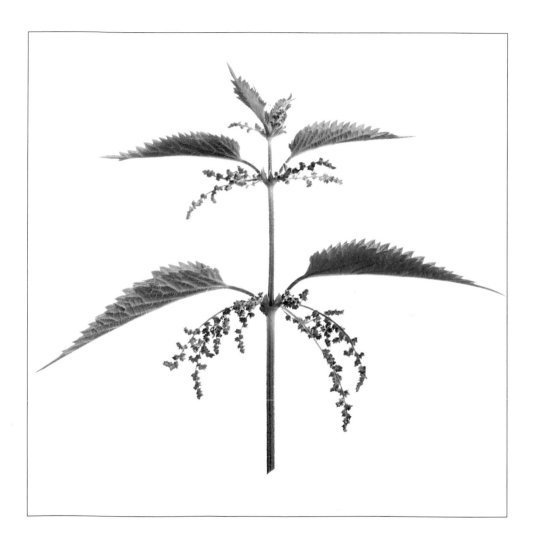

ALLIUM

Allium is the Latin name for onion. Among the species in the genus is a handful of culinary treasures — leek, chive, shallot, garlic; if you accidentally let them run to seed you can at least enjoy their striking umbels of flowers. Ornamental alliums play variations on the theme in a wide range of shapes and colours.

Scent is not one of their attractions: many smell somewhat oniony. But our distinction between the useful and the beautiful is largely cultural. Consider: the madonna lilies we admire were once a food crop in Turkey, and Japanese golden-rayed lilies were relished scale by scale — like an artichoke — on the slopes of Mount Fujiyama.

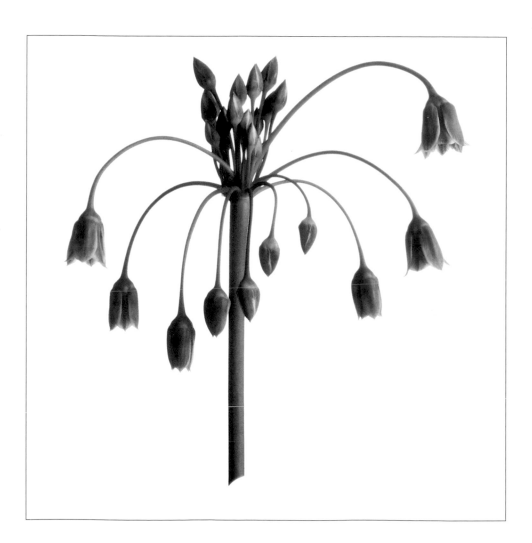

MALE FERN

*The 'maleness' of this fern probably stems from its crown-like
shoots with kingly, masculine connotations. (Lady fern is
correspondingly dainty and elegant.) Gender doesn't actually come
into it. For centuries all ferns' reproduction remained mysterious.
They are cryptogams – * crypto *(secret, hidden) and*
gamos *(marriage).*

*They were thought to bloom once only, at midnight on St John's
Eve, the flowers remaining invisible for the rest
of the year and new plants being engendered by some unknown
vital force. These supposed properties led ferns to be used
as charms against evil spirits, to promote valour, and to render
people invisible.*

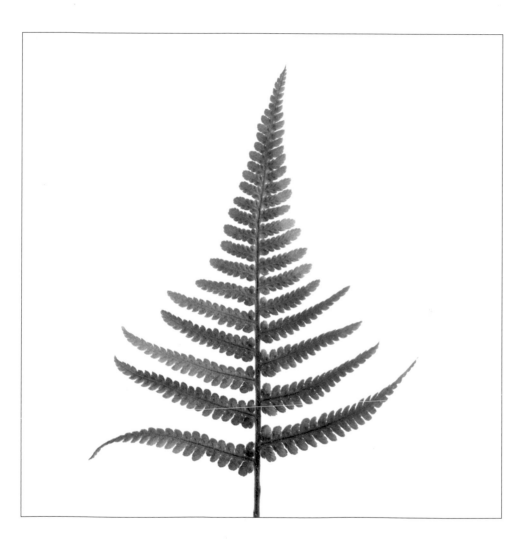

COMFREY

The English word 'comfrey' and the Latin name 'Symphytum'
both contain hints in their makeup of the healing role of
this plant in ancient medicine. The common names 'knitbone' and
'boneset' more clearly record the value of the leaves in reducing
inflammation when applied to wounds.

People once took infusions internally and used the leaves
to gargle, but their current role is to nourish plants as a potash-
rich fertilizer. Organic gardeners also add leaves to the
compost heap to act as accelerators and layer them in bean trenches
as green manure. Various species and garden forms make good
coarse ground cover in shaded areas.

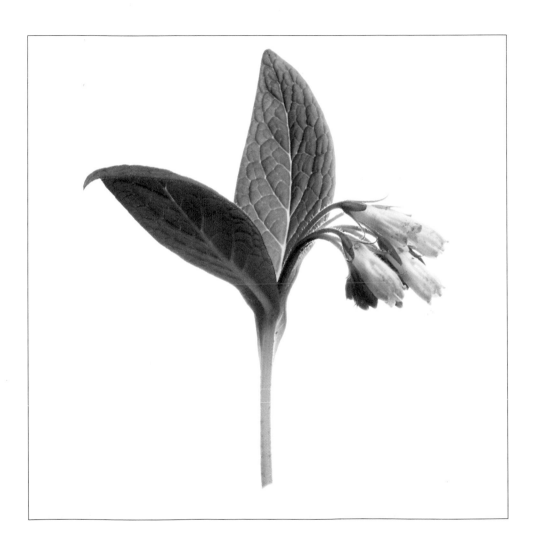

PERENNIAL
CORNFLOWER

Proud, tattered blue banners draw attention to a thistle-like inflorescence. Humans and hungry insects alike are attracted by the display. But the outer circle of florets is barren, just for show. The real business takes place among the less flamboyant fertile flowers at the centre, where pollen is released to the thrust of visiting insects.

This cousin of the annual cornflower is a naturalized garden escape in Britain. Deep, brittle taproots make it difficult to eradicate once it has colonized a site. The light felting on the leaves – a sun filter – betrays the plant's alpine origins, high on the mountains of southern Europe.

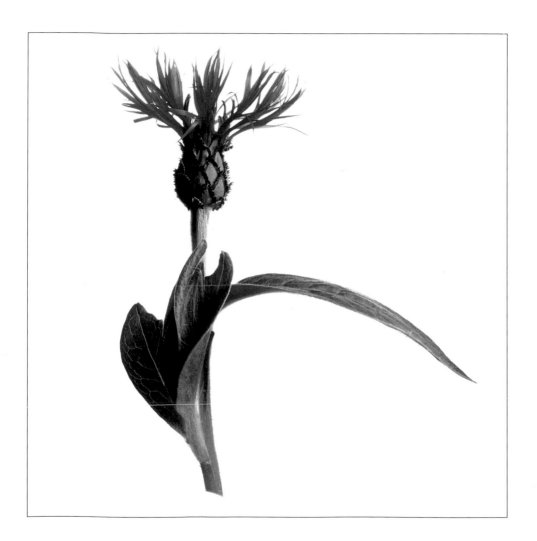

COWSLIP

Gone are the days when you might freely pick 'three handfuls cowslips' to make cowslip cream, let alone a gallon of the petals for cowslip wine. Though locally common, the plant is becoming distinctly rarer. Our ancestors are partly to blame for over-indulging, not only at table but in medicinal potions.

One, it was claimed, 'doth marvelously strengthen the Braine, preserveth against Madnesse, against the decay of memory, stoppeth Head-ache and most infirmities thereof'. Modern agriculture, too, is eliminating suitable habitats, though cows still furnish the onomatopoeic 'slyppe' or dung in which the plants were supposed to thrive.

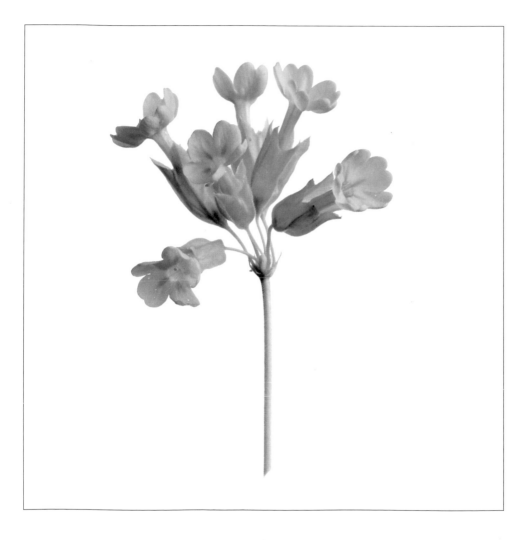

DANDELION

*What's the time by the dandelion clock? A deep breath. Huff!
One o'clock. Puff! Two o'clock. And so on until all the seeds have
been blown off to ride the wind on their little parachutes.
The tonsured dome you have left is sometimes called 'monk's
head'. The name dandelion –* dent-de-lion *– comes from
the toothed leaves.*

*'Piss-a-bed' alludes to the laxative properties of the vitamin-rich
leaves (well worth adding to salads when
young). You can roast and grind the roots as a substitute for coffee,
brew wine and beer from the flowers and even
use the milky sap of some species to make rubber.*

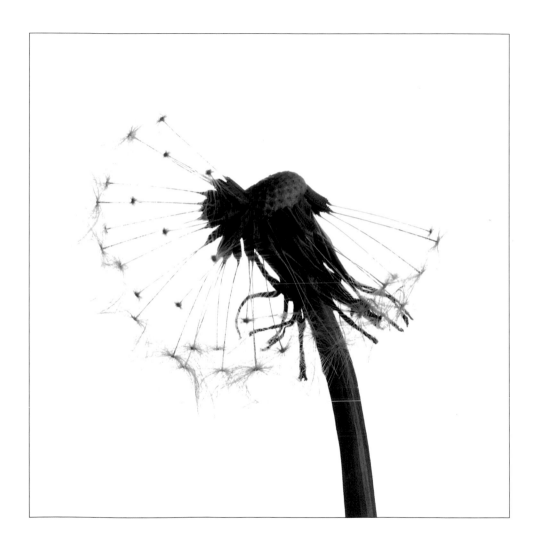

Rose Hip

*To people of a certain age, rose hips evoke a rosy glow of memory.
The wartime government decreed that infants should drink
rose-hip syrup for vitamin C. Country children were deployed to
gather hips and paid at the rate of threepence per pound.*

*Oval dog-rose hips were not only most abundant but high in
precious vitamin content – up to twenty times that
of oranges. The black hips of burnet roses were even richer, but
much harder to find and collect. You had to strain the pulp
carefully to remove all the hairy seeds. Nasty children sometimes
put these down your back as 'itching powder'.*

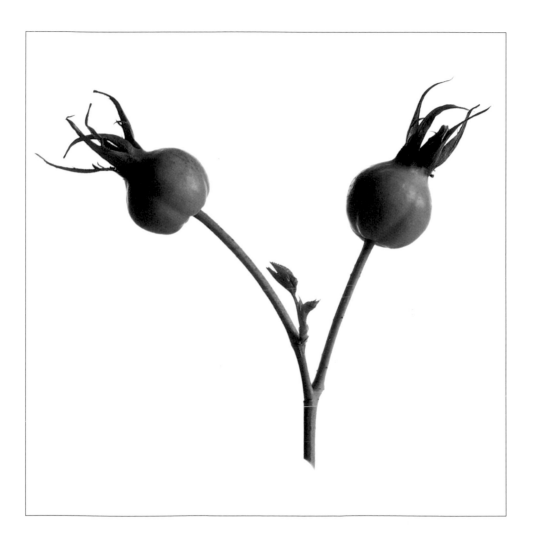

BUTTERCUP

*'Do you like butter?' they used to say, holding a gleaming
flower beneath your chin. If your throat shone yellow this meant
you did – perhaps more a reflection of the greasiness of your
complexion than of what you spread on your bread.*

*Buttercups were supposed to improve the colour of the
milk, but only by being rubbed into the beast's udders; feeding her
fresh flowers could be fatal, for buttercups are poisonous.
Their acrid taste makes animals avoid them when grazing in
flowery meads, and fortunately the plant loses its toxicity
when cut and dried as hay.*

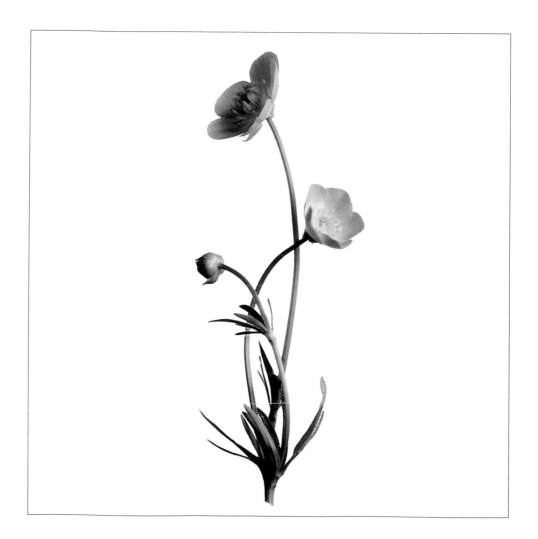

Lenten Rose

*Shapely, stately, just slightly sinister, the hellebores seem
timeless. Long-lasting papery sepals, faintly watermarked, surround
a boss of stamens and styles in an ancient, primitive flower
structure evolved before insect life became sophisticated. Once
hellebores were used medicinally: one can only wonder with what
effect, since the entire plant is highly toxic.*

*Lenten roses are among the hellebores that hybridize
with enthusiasm. Seeing how the progeny turn out is exciting – in
colour permutations ranging from smoky blacks and murky
purples through dusty or pearly pinks to green-tinged white, subtle
or dingy according to taste. Some have speckled centres, like this
faintly blood-bespattered individual,* Helleborus orientalis guttatus.

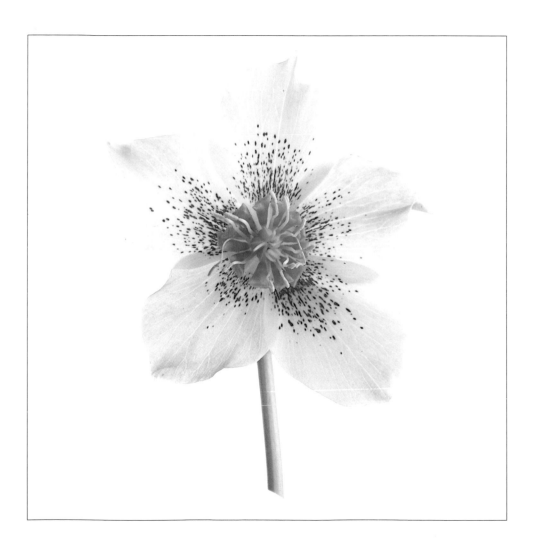

CROSSWORT

Tiny starry yellow flowers cluster in whorls, making up in
numbers what they lack in size to attract bees and flies with a
sweet honey scent. The 'cross' in the name derives
from the arrangement of leaves in fours around the stem.

The plant is closely related to sweet woodruff and to
Our Lady's bedstraw, which legend has it was strewn on the bed
where Mary gave birth to Jesus (miraculously, it was turned
from white to gold as a reward for its role during this event). A less
charismatic relative is goosegrass or cleavers, with its sticky burrs.

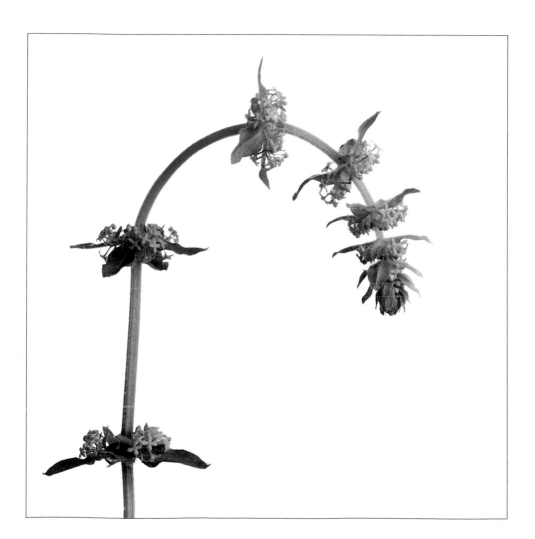

KNAPWEED

Atop tough, rigid flowering stems the tightly furled buds make distinctive blobs. These are the 'hardheads' of the plant's alternative common name. The 'knap' in knapweed is related to 'knob' – again referring to the shape of the bud.

The closed bud is ornamented with a diaper pattern of overlapping bracts. It opens to reveal a mass of disc florets, larger around the margins than at the centre. And, hard-headedly, the fertile florets release pollen only when an insect alights on the flower, thus ensuring it is fresh and potent.

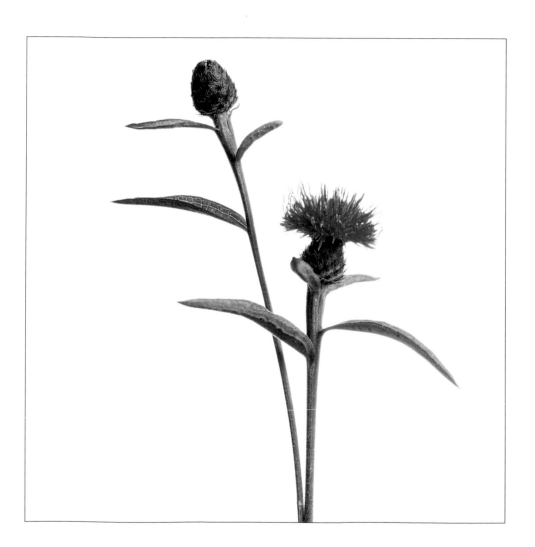

CROCUS

*Anyone who thinks of a crocus as a fragile, decorative
thing should consider the sheer force and calculated mechanisms
of the plant. The sheathed growing tip of crocus leaves thrusts
through icy ground 'in much the same way that you put
your two hands together and hold them in front of your head
when diving into the water', as gardener E.A. Bowles put it.
An emergent flower has special metabolic warmth that
helps melt surrounding snow, and to protect its pollen it opens
and closes in response to weather conditions.*

*In a saffron crocus, those three stigmas are glowing red.
It takes half a million flowers to produce a kilo of flavoursome
dried stigmas.*

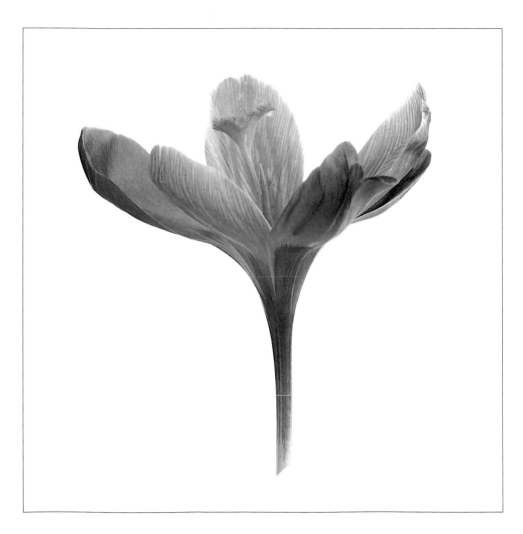

BRACKEN

*Thuggish bracken flexes its muscles, prepares to unfurl its
handsome aquiline fronds and spread its dominion over new
terrain. Poisonous to horses and cattle, carcinogenic to
humans, a blight on the landscape, it once had some uses: it
was gathered as bedding for livestock and burnt to make potash
in pre-industrial times.*

*Now, unless its young shoots are checked by grazing
and trampling, bracken inexorably spreads its monotonous blanket
over species-rich heathland and pasture. The progress of the
creeping rootstock, which physically smothers competition, is
fiendishly aided by phenolic compounds, which accumulate in the
soil and inhibit the growth of neighbouring plants. Quite the
villain of the piece.*

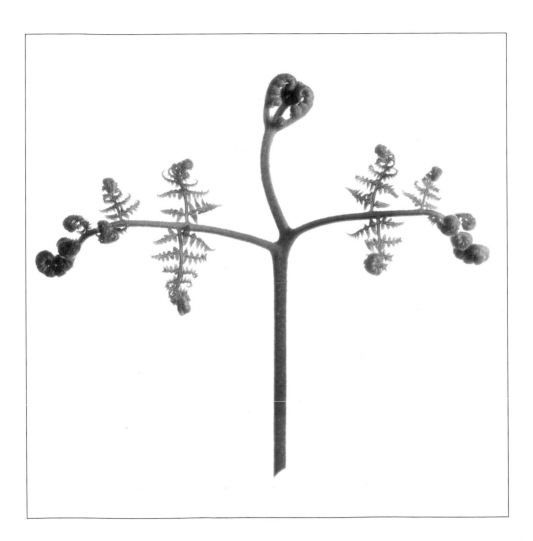

POPPY

With their crumpled silk petals around a pepper-pot
seed capsule, the poppies rival the repertoire of a sari shop
in their spectrum of singing colours. Oriental poppies
and field poppies specialize in brilliant reds; Shirley poppies
come in pastel pinks and lilacs; Californian poppies offer
a mouthwatering sherbet collection of lemon, peach, apricot.

The genus Meconopsis *has our Welsh poppy in sunny yellow*
and glowing orange − and then, halfway round the world,
produces the divine sky-blue of the Himalayan poppy.
Plant hunter Kingdon Ward recalled discovering them in the
1920s, 'like a blue panel dropped from heaven − a stream
of blue poppies dazzling as sapphires'.

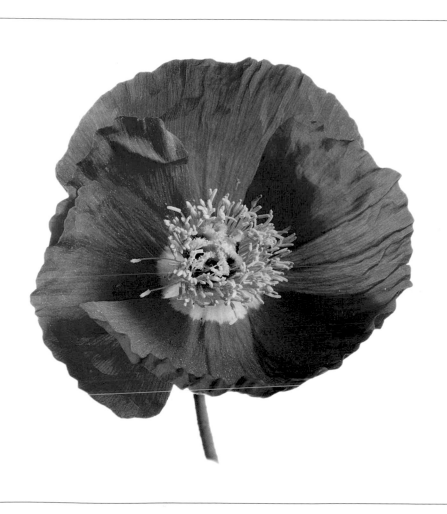

COCKSFOOT

*We too seldom study nature in close-up. This single
stalk of budding cocksfoot — its spare lines caught in a few
brushstrokes — has the economy of a haiku.*

*Look even more closely: through a magnifying lens you see
the intricate beauty of grasses' flower structure, while rolling off
your tongue delicious terms like 'glume' and 'lemma'.*

*When the flower panicles open they look something like
a cock's foot. The botanical name is* Dactylis glomerata *(jointed
like a dactyl or finger, with flowers 'agglomerated' in clusters).
This stout grass is valued for grazing. Old-time New Zealand
settlers gathering the seed coined a new verb and put 'cocksfooting'
along with shearing into the farming calendar.*

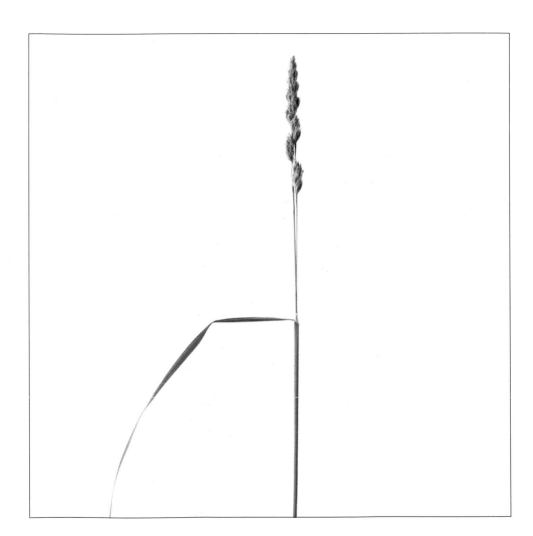

YELLOW FLAG

*The floral parts of the iris are specially organized
to transmit come-hither messages to bumble bees. The 'fall'
petals are landing platforms decorated with guide marks.
Creeping under the flap-like stigma, which dexterously scrapes
off any pollen from a previous flower, a bee is daubed
by fresh pollen as it approaches its nectar reward. A curling
mechanism as the bee backs out prevents this pollen
from being removed.*

*In the last century the opulence of irises also attracted
fin-de-siècle artistes-nouveaux and* Yellow Book *sensualists. In a
more chaste, stylized form – as a three-lobed silhouette – the
iris was the fleur-de-lys of heraldry and symbolized the Trinity.*

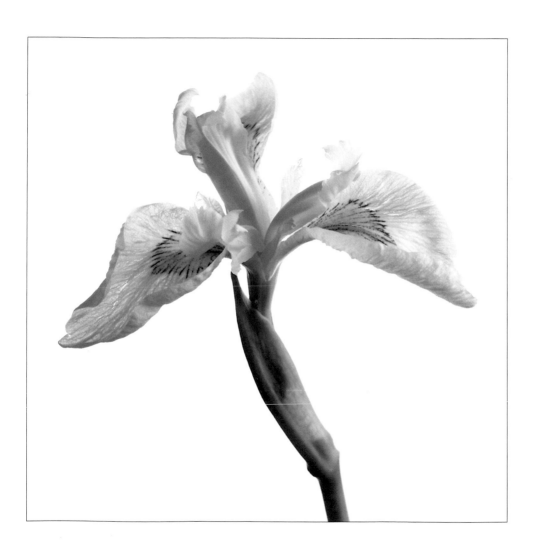

ANGELICA

*Our ancestors dubbed this plant 'angelic' because of its many
medicinal properties. All parts were valued – the nectar-laden
flowers, aromatic leaves, ribbed stem and root pungent with volatile
oil. Angelica was supposed to ward off evil spirits; it was
carried as a defence against the plague and 'all infections taken by
evill and corrupt aire'. Less angelic, perhaps, was
the use of the seeds as an ingredient in gin and absinthe.*

*We are safer getting the familiar candied stems
ready-made rather than as wild food, lest any confusion
occur between this saintly, majestic plant and its
lethal look-alikes – hemlock, cowbane and water dropwort.*

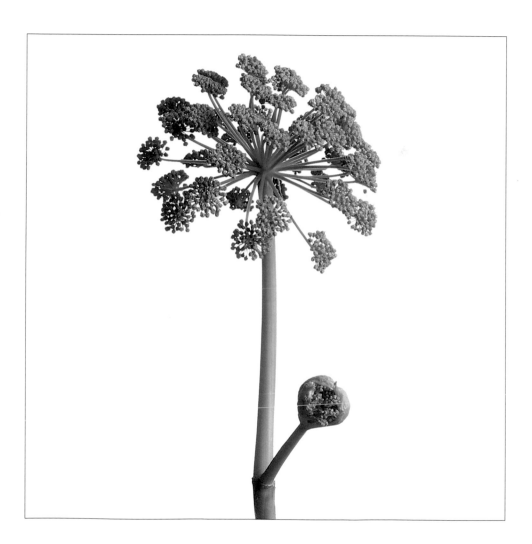

DAISY

Disarming daisy, the epitome of simplicity. The 'day's eye' modestly shuts its white 'lashes' at night and when it rains. What could be more charming? Chaucer loved it best 'of alle the floures whyte and rede', in an age when it was highly valued as a medicinal herb.

Each 'flower' is, of course, a composite of many white (female) ray florets and a hundred or more yellow (hermaphrodite) disc florets — all functioning together like a single bloom. But the 'dissembling daisy' also symbolizes fickleness and deceit. And some daisies make their neighbours droop: flower arrangers avoid mixing them because of their toxic exudations.

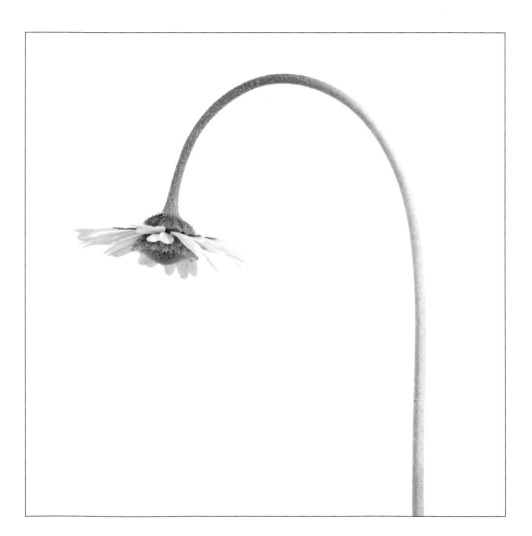

RAGGED ROBIN

*A meek-looking distant relative of the glamorous pinks
and carnations, ragged robin flowers in damp meadows in spring,
in cuckoo time (hence the species name* flos-cuculi, *flower
of the cuckoo). More prosaically, the leaves are often daubed with
cuckoo-spit, the froth produced by leaf-hopper larvae.*

*The deeply cleft petals have a fragile, tattered charm, an image
that appealed to Tennyson when he wrote that King Arthur's
knight Geraint – falling in love with Enid at the wayside in her
faded silks – might be thought to have 'pick'd a ragged
robin from the hedge'.*

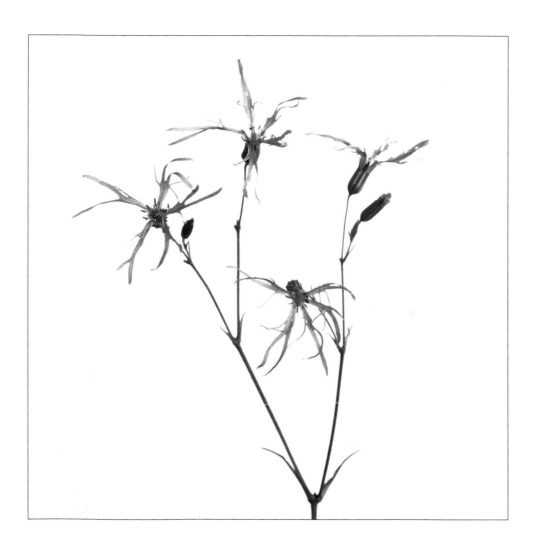

BUGLE

*Whorls of alluring blue flowers with protruding lower lips
invite insects to investigate their charms. In the seventeenth century
when all plants were still thought to be governed by one of
the planets or by the sun, the physician Culpeper attributed the
lovely bugle to the dominion of 'Dame Venus'. His
recommendations included a syrup to take internally and an
ointment to use externally. One decoction was said to be
'very effectual for any inward wounds, thrusts or stabs in the
body or bowels'.*

*Today we are more likely to apply the bugle's variously
coloured forms to our gardens, where the creeping habit suggested by
the Latin* reptans *indicates its use as carpeting ground-cover.*

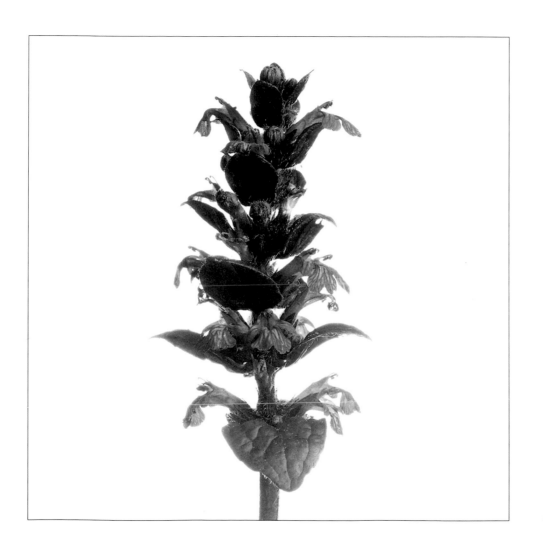

WAYFARING TREE

In wilder landscapes 'wayfaring trees' often serve some useful function, storing water for thirsty travellers or pointing the direction like a signpost. Britain's native version, Viburnum lantana, *commonest in the chalk downland of southern England, plays a more ornamental role. Growing along roadsides and in hedges – perhaps planted there deliberately – its attractive form simply gave pleasure to those passing by, a sort of travellers' joy.*

The Tudor herbalist Gerard called it the wayfaring man's tree. The umbels of white flowers ripen to clusters of red and then black fruits.

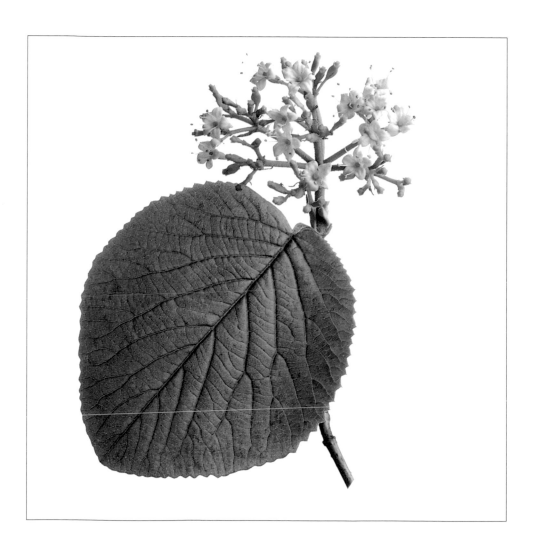

FOXGLOVE

Devil's fingers, dead men's bells – the witchery of the foxglove lies not only in its connotations of danger. The drug digitalin, which affects the heart muscles, is a potent poison. But the foxglove also displays impressive prestidigitation in working with the bumble bee to assure reproduction. The lowest buds open first. Newly opening foxglove flowers are at the male stage. Visiting bees carry away their pollen and deposit it on the next plant they visit – systematically spiralling up from the bottom of the flower spike, where the older flowers have turned into receptive females.

Why fox? The Norwegians talk of 'foxbells'. But the English name may derive from 'folk's glove', referring to the little folk or fairies. An Irish name is fairy thimble.

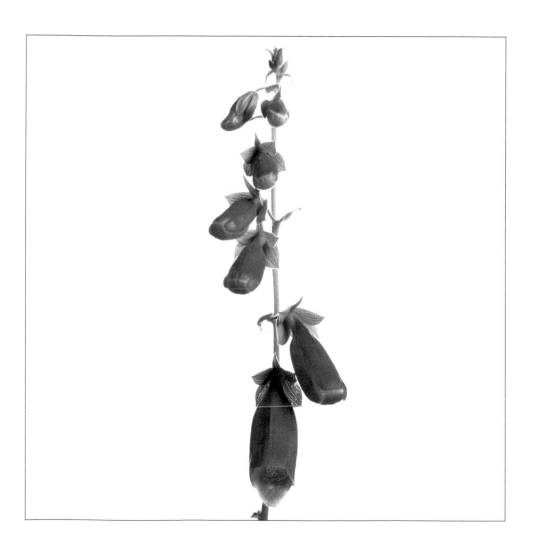

RAMSONS

Wild garlic – Allium ursinum *– is a stunning spring
sight in woodland valleys, with heads of charming starry flowers
set against a satiny weave of ribbon-like leaves. This feast
for the eye packs a punch for the nose: the vision is accompanied
by a powerful oniony smell, particularly after rain or when
the leaves have been bruised. It is quite enough to taint the flesh
and milk of browsing animals. You can eat young leaves in
salads or use them as a flavouring – but with discretion, for they
can be overwhelming. The bears (*ursi*) after whom this allium
is named must have had strong stomachs.*

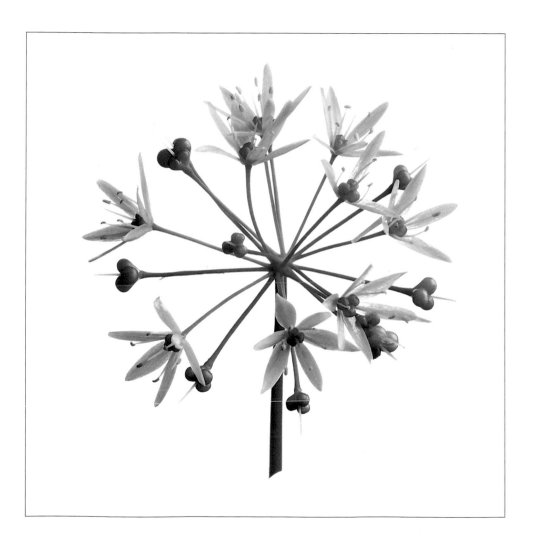

DAFFODIL

The name 'daffodil' was once 'affodill', derived from 'asphodel'.
Asphodels were the immortal flowers that covered the
Elysian meads. They are supposed to have been white until
Persephone let some fall as she was being carried off by
Pluto in his chariot. Someone brought the name north and used
it for other lily-like yellow flowers they found growing in
profusion – our daffodils. Cases of mistaken identity still happen,
like the Oriental student of Wordsworth who
rhapsodized over a host of golden dandelions when he
first visited England in spring.

Here the just-unsheathed bud is poised, mute,
before its trumpet-flower emerges to blow in the March winds.

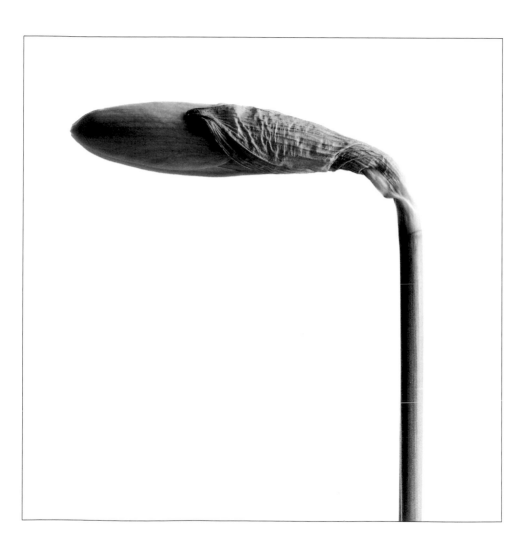

DOG ROSE

Our most common hedgerow rose has been dogged by
the canine connection since the days of Pliny, who called it
cynorrodon, *literally 'dog rose': the ancient Greeks*
thought the roots of the plant could cure the bite of a mad dog.
This pedigree puts paid to the suggestion that 'dog' is a
corruption of 'dag' and refers to the dagger-like thorns.

The dog rose symbolizes 'pleasure mixed with pain' in
the language of flowers. Some of the pleasure principle presumably
stems from the flower's appearance. Its very simplicity
means it is fertile and capable of maximizing seed production
in sumptuous hips. Roses with more decorative double
flowers are sterile.

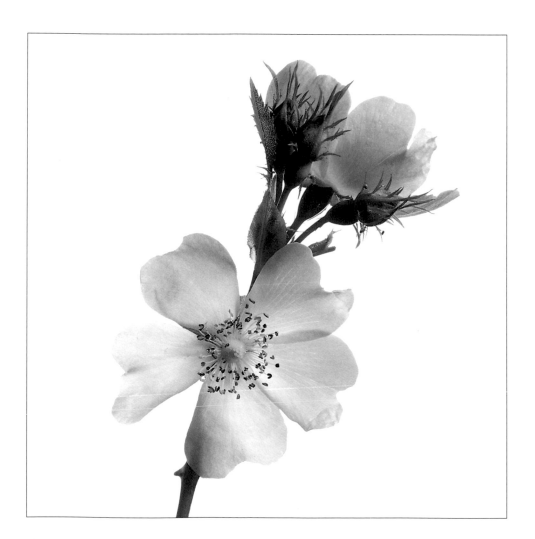

VETCH

*On making contact with something they can count
on for support, those gently caressing tendrils will turn into
determined clinging coils. Together with the keeled flowers
(followed by distinctly pea-like seed pods), the questing
tendrils remind us that this is the pea family. The word 'vetch'
is related to* Vicia, *the genus which contains the broad bean.*

*The grass is greener where vetch grows. High protein
content makes it valuable as fodder, and the roots fix nitrogen
in the soil to act as a natural fertilizer. Droplets of
nectar secreted from the leaf stipules are not intended to attract
pollinators, but are a waste product, food for ants.*

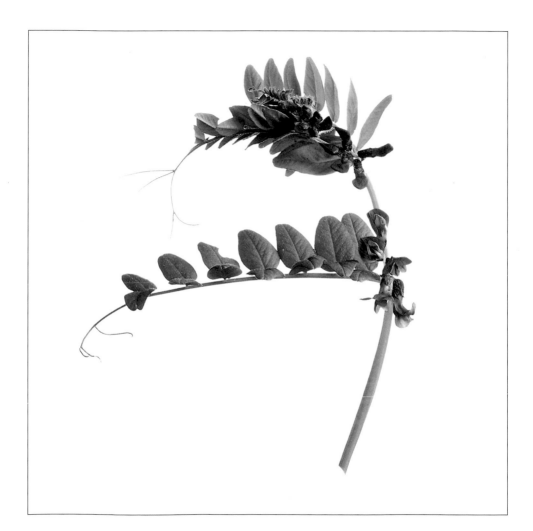

Rape

*The breeders have long had their way with the genes of the
versatile* Brassica *genus. Cousin to turnips, cabbages and
mustards, rape is closely related to the swede. Its name comes from*
rapum, *meaning turnip. Rape crops are grown for the oil-rich
seed, so plants are bred to put energy into producing flowers and
setting bigger and better seeds.*

*Now our landscape has become assaulted – raped – by
abstract panels of fluorescent yellow. En* masse, *the flower heads
(standing erect for easier harvesting) catch the light unmuted
by a pointillism of sobering foliage. The smattering of
greenish buds and stems merely adds that hint of acidity
to the dazzling hue.*

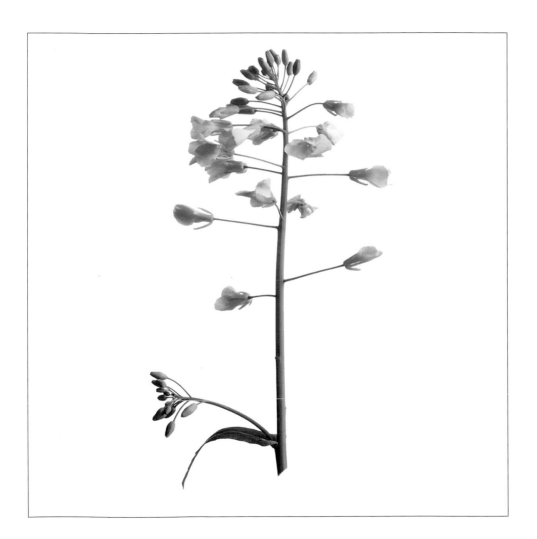

HONEYSUCKLE

Honeysuckle suggests bees, but this plant had moths in mind when it evolved its shapely, night-scented trumpets with no place for bees to land. A hawkmoth can hover in front of a flower, its long proboscis probing the depths of the tube in search of food. Meanwhile the outstretched anthers and stigma touch the moth's body to exchange pollen from flower to flower.

It is honeysuckle's winding, binding ways Titania has in mind as she takes Bottom in her arms – 'So doth the woodbine, the sweet honeysuckle, Gently entwist'. Not always so gently: it can hug a sapling so tightly that it tortures the wood into corkscrew spirals, specially sought after for walking sticks.

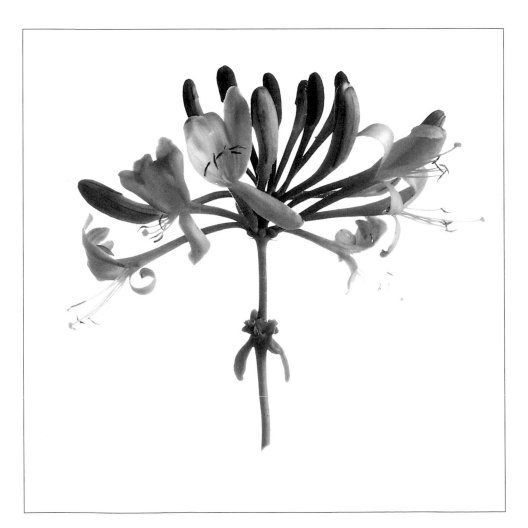

SOLOMON'S SEAL

The knobbly-kneed rootstock is the source of the genus name Polygonatum, *and the circular scars on its surface – left by decaying stems – reminded people of a sigil or seal. Specifically they made people think of that six-sided symbol we know as the Star of David, also known as Solomon's seal.*

The plant was long valued for medicinal properties: Dioscorides in the first century recommended its use 'to seal or close up green wounds'. Its elegance, too, is much admired. A Victorian writer waxed lyrical about its 'pendent drops . . . which hang like waxen tassels under the full and regular leaves'. John Parkinson, the sixteenth-century gardener and herbalist, called it 'ladder to heaven'.

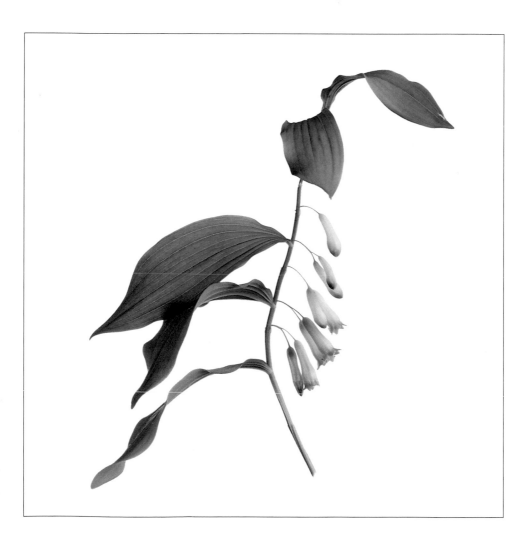

THISTLE

*The marsh thistle, like others of the family, defends
itself against grazing animal predators with a vicious armoury
of prickles on the leaves and down the winged stem. Only
the composite flower head offers a soft landing place for bees and
butterflies. No wonder a cousin – the Scotch thistle – was
chosen by a medieval king of Scotland as a symbol of defence.*

The Doctrine of Signatures *in early medicine, which held that
a plant's appearance indicated its possible virtues, claimed
that thistles were efficacious for 'the prickles', or a stitch in the side.
Hungry people have braved the fortifications, peeled
off the prickles and eaten the inner stems.*

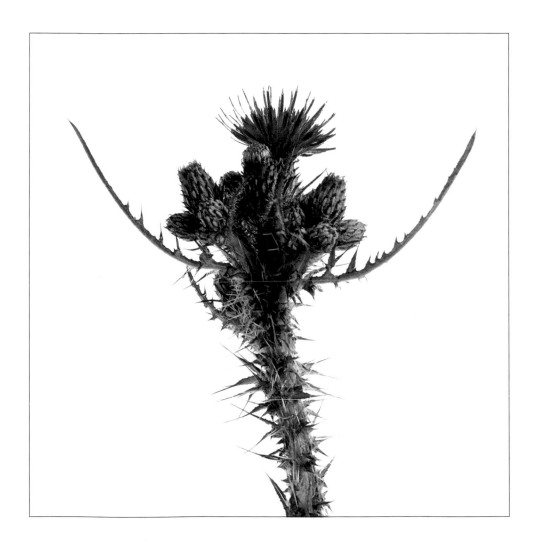

Yellow Archangel

*The stingless leaves of the dead-nettles (or 'blindnetle'
or 'deffe nettylle') can be used as a pot-herb. John Gerard claimed
the flowers of the red kind could be 'baked with sugar, such
as roses are'. Yellow archangel is supposed to open on the feast day
of the Archangel Michael.*

*The labiate blooms attract long-tongued humble-bees
as well as human appreciation. The upper lip rises hood-like to
protect the anthers and stigma; the lower lip is mottled with
bee-guides.* Lamium, *the genus name, comes from the Greek for
'throat', which reflects the appearance of the blossoms.*
Galeobdolon, *archangel's specific name, is less enticing; it
alludes to the plant's weasely smell.*

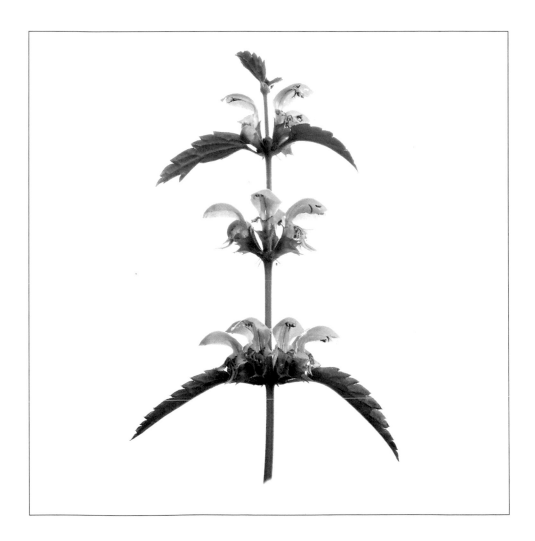

BLUEBELL

*The enchanting blue haze of our spring woods is the
envy of Europe: only in Britain and a few westerly pockets of
the Continent are conditions right for such profusion. Our
woodland carpets are woven from the dangling tubular bells of*
Hyacinthoides non-scripta. *Clusters of more open,
upright bluebells in hedgerows are often the introduced*
H. hispanica, *or hybrids between the two.*

*Calling them 'English Hare-bells', Gerard noted the uses of
the clammy juice – 'to set feathers upon arrows in stead
of glew, or to paste books with', and also to make a high-quality
starch. We hope people didn't lick their fingers as they
worked, since bluebells are poisonous.*

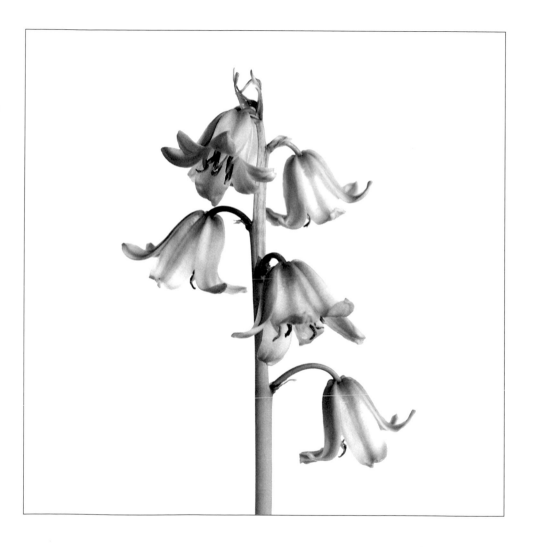

WILD STRAWBERRY

The fruits that will ripen from these flowers
may be smaller and more fiddly to gather than
their cultivated cousins, but they will far outweigh them for sheer
quality of flavour. Meanwhile, you could infuse some leaves:
with their tannin content, they make a drink like China tea.

In medieval paintings the plant symbolizes temptation.
The Madonna in The Virgin of the Strawberries *is depicted*
sitting calmly on a bank of strawberries impregnable to their
charms, but Hieronymus Bosch shows the terrible fate
of those who succumb — they turn into monsters. Gourmets
more likely. Bon appetit.

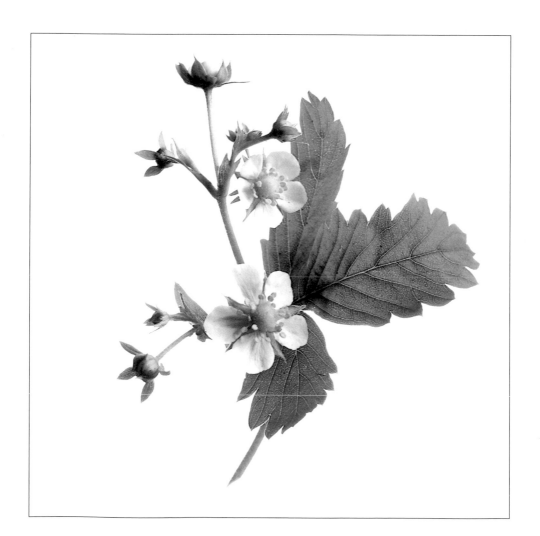

COMMON SPOTTED ORCHID

*This pale form displays its intricate blooms and waits
for a visiting bee. When one probes a flower in search of nectar,
it will emerge with blobs of pollen stuck to its head with
adhesive pads, and transfer this to another flower. The botanist
Anthony Huxley called the orchid flower 'a device for taking
advantage of insects'.*

*This is pretty restrained stuff compared with some orchid
antics, however, where the flower's scent and shape so accurately
imitate a female insect that the male of the species is seduced.
Orchid flower structure generally, Huxley thought, 'conceals a sex
life so elaborate that it reminds one of the Kama Sutra'.*

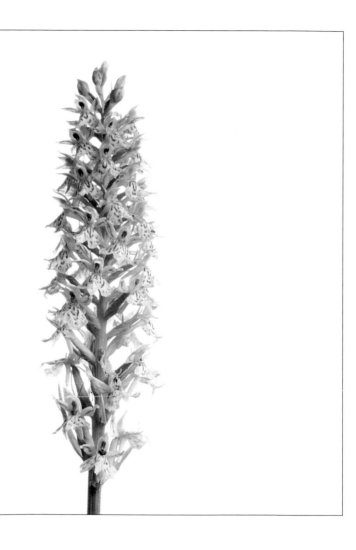

HERB ROBERT

Who is Robert? What is he? The eponymous hero of Geranium robertianum *is variously cited as a Norman duke or abbot, canonized as St Robert and elevated to the papacy. Perhaps in those dark unwashed ages it was the smell of some Robert's feet that provided the link, for the ethereal oils in this dainty little cranesbill with the filigree leaves emit a distinct pong, familiar to weeding gardeners.*

An alternative name was bloodwort — shared with other plants whose reddish stems and red-tinged leaves were supposed to staunch bleeding. The beak-like shape of the seed capsule inspired the names 'cranesbill' and 'geranium' (from the Greek geranos *meaning 'crane').*

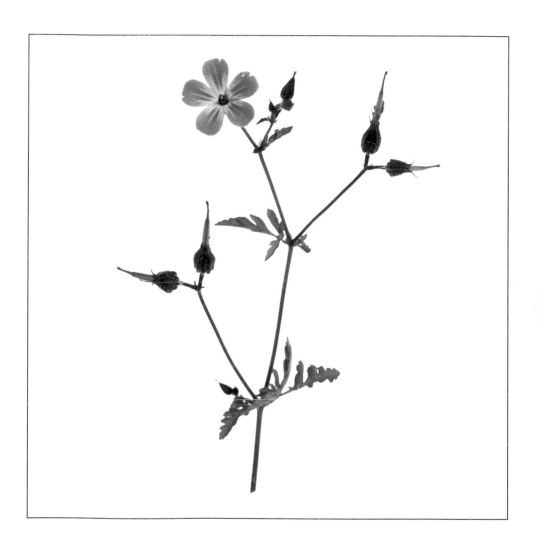

Acknowledgements

I would like to thank the following people: Penny David for her research and for writing the descriptions of the flowers with such wit and scholarship; Ray Watkins for her meticulous layout and design, and her enthusiasm throughout; Thomas and Pepe Messel for hours of helping to gather the flowers; Graham Piggott for his long-suffering and tireless assistance; Sir Roy Strong for writing the Foreword; Colin Webb, Tim Clarke and Kate Quarry at Pavilion Books for their kindness in publishing this small book; Graphicom in Italy.